RIKACO'S BASIC

CONTENTS

DEMIM	4
TRENCH COAT	14
BIKER JACKET	20
BLAZER	28
PEARL	34
KNIT WEAR	42
DUFFLE COAT	50
TURQUOISE	56
SNEAKERS	64
PUMPS	72
ENGINEER BOOTS	76
T-SHIRT	80
SHIRT	88
SWEAT WEAR	98
SCARF	106
WATCH	112
BAG	116
SOCKS	122
EYEWEAR	126
DAILY COORDINATE	132
ARCHIVE	140
RIKACO X STYLIST COLLABORATION	146
SHOP & PRESS LIST	158

ずっといい関係でいたいもの

デニムは安心感とドキドキを併せ持つもの。無条件に信頼がおけるユニホーム的な部分もあり、時代が集約されるシビアなアイテムでもあります。シルエットやサイズ、その時々の微差にこだわってリニューアルをし続けることが大切。私は10代で出合った「リーバイス 501」と60歳になってもいいリレーションシップでいることが理想。

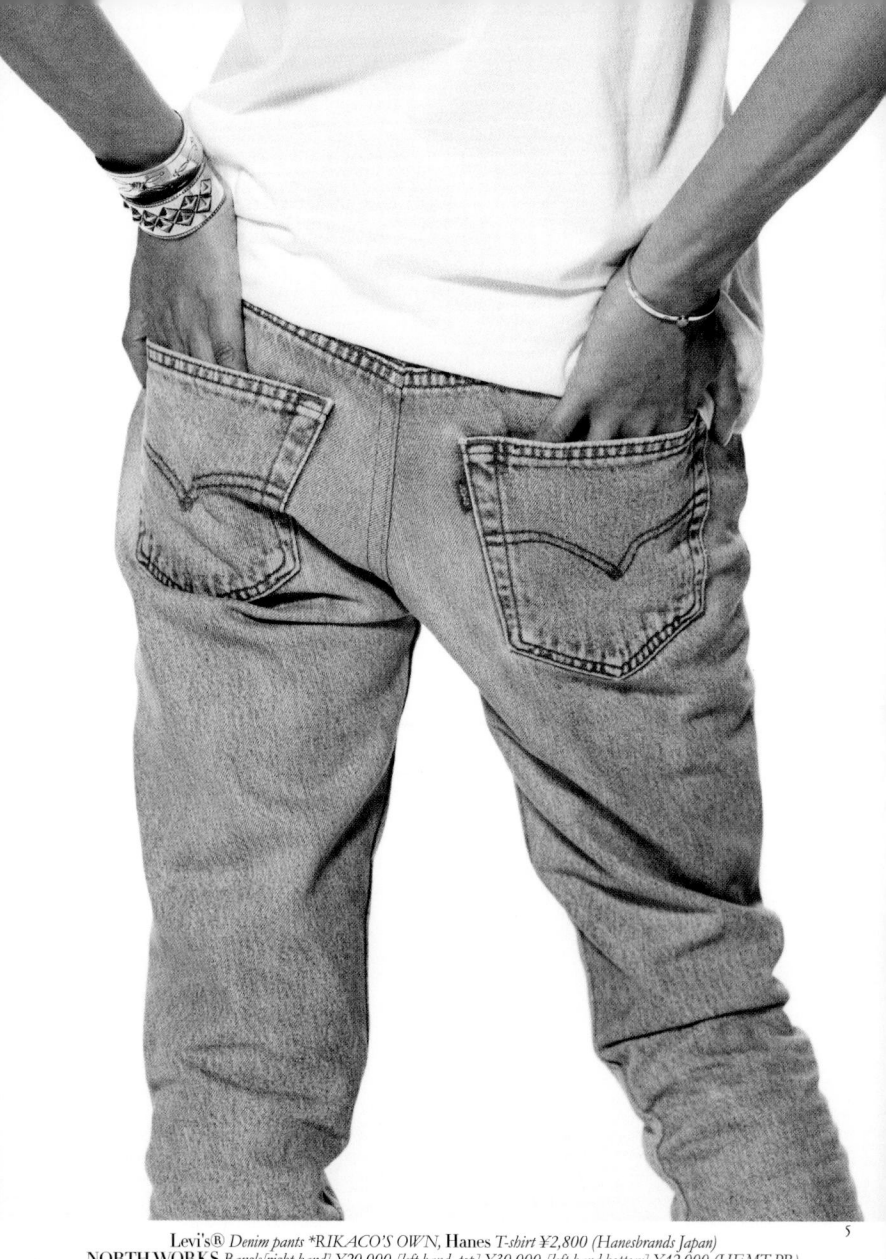

Levi's® *Denim pants* *RIKACO'S OWN*, **Hanes** *T-shirt* ¥2,800 *(Hanesbrands Japan)*
NORTH WORKS *Bangle[right hand]* ¥20,000 *[left hand, top]* ¥30,000 *[left hand bottom]* ¥42,000 *(HEMT PR)*

Levi's® *Denim pants* *RIKACO'S OWN
Hanes *Thermal T-shirt* ¥1,800 (Hanesbrands Japan)
MANOLO BLAHNIK *Pumps* ¥99,000
(BARNEYS NEW YORK)
Scye *Belt* ¥26,000 (Masterpiece showroom)
JANE SMITH *Scarf* ¥8,000
(HEMT PR)
Trench coat, Bag *RIKACO'S OWN

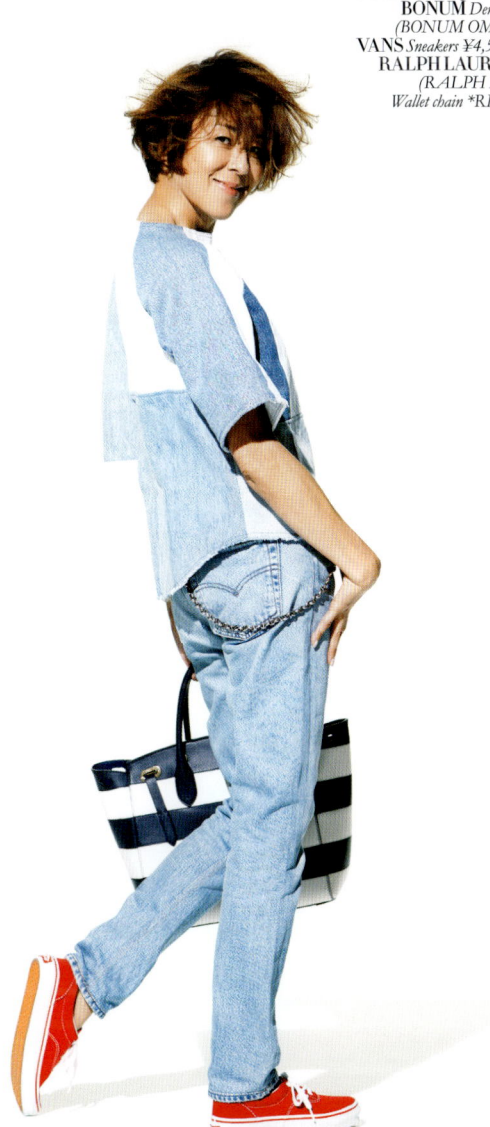

Levi's® *Denim pants* *RIKACO'S OWN
BONUM *Denim top* ¥17,000
(BONUM OMOTESANDO)
VANS *Sneakers* ¥4,500 *(VANS JAPAN)*
RALPH LAUREN *Bag* ¥420,000
(RALPH LAUREN)
Wallet chain *RIKACO'S OWN

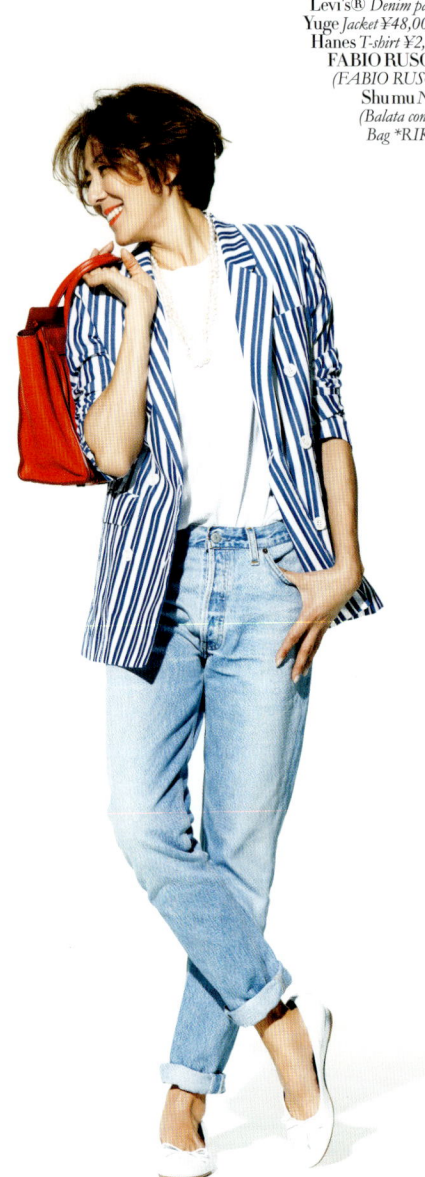

Levi's® *Denim pants *RIKACO'S OWN*
Yuge *Jacket ¥48,000 (5eme VISAGE co.,ltd)*
Hanes *T-shirt ¥2,800 (Hanesbrands Japan)*
FABIO RUSCONI *Pumps ¥17,000*
(FABIO RUSCONI ROPPONGI)
Shu mu *Necklace ¥21,000*
(Balata concierge Press Room)
Bag *RIKACO'S OWN*

Levi's® *Denim pants *RIKACO'S OWN*
ENFOLD *Sleeveless top ¥21,000*
(BAROQUE JAPAN LIMITED)
PELLICO *Pumps ¥46,000*
(TOMORROWLAND)
a.v.max *Bangle ¥8,500*
(COCOSHNIK ONKITSCH
YURAKUCHOMARUI)
Bag, Pierced earrings
**RIKACO'S OWN*

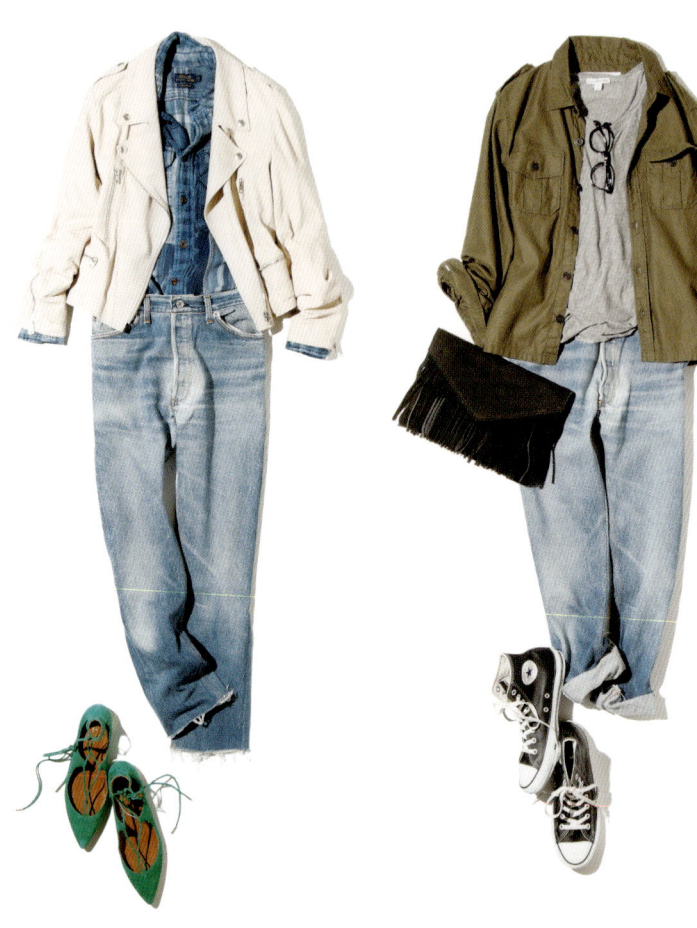

MOTHER *Denim pants*
¥34,000 *(The SAZABY LEAGUE)*
Rawtus *Biker jacket* ¥98,000
(RAWTUS INTERNATIONAL)
POLO RALPH LAUREN
Shirt ¥34,000 *(RALPH LAUREN)*
AQUAZZURA *Pumps* ¥78,000
(TOMORROWLAND)

MOTHER *Denim pants* ¥34,000 *(The SAZABY LEAGUE)*
Serra Retreat *Shirt* ¥22,000 *(GUEST LIST)*
JAMES PERSE *T-shirt* ¥18,000
(JAMES PERSE AOYAMA)
OLIVER PEOPLES *Glasses* ¥30,000
(OLIVER PEOPLES TOKYO GALLERY)
BAGMATI *Bag* ¥13,000 *(journal standard L'essage GINZA)*
Sneakers *RIKACO'S OWN

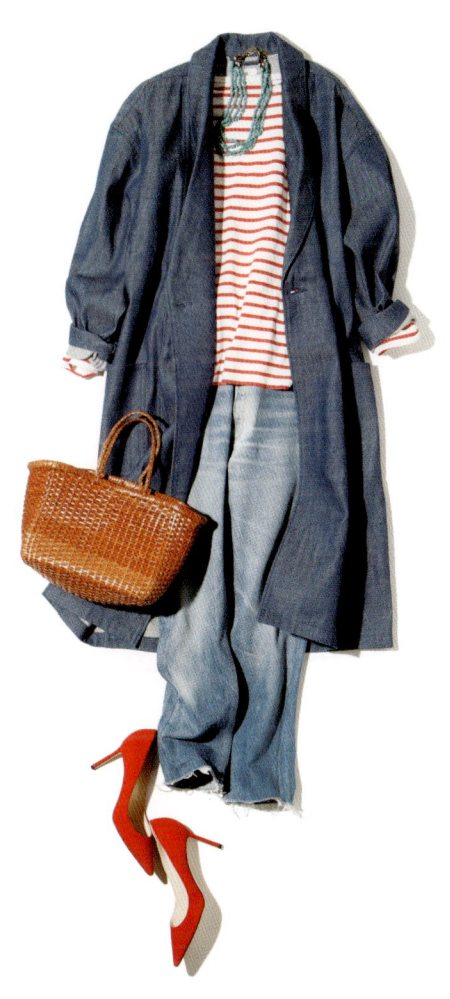

MOTHER *Denim pants* ¥34,000 *(The SAZABY LEAGUE)*
SEA *Top* ¥22,000 *(S-STORE)*
JIMMY CHOO *Pumps* ¥74,000
(JIMMY CHOO)
Shu mu *Necklace* ¥19,000
(Balata concierge Press Room)
Denim coat, Bag *RIKACO'S OWN

RALPH LAUREN COLLECTION
¥71,000
(RALPH LAUREN)

JANE SMITH
¥17,000
(HEMT PR)

REDCARD
¥19,000
(GUEST LIST)

BONUM
¥26,000
(BONUM OMOTESANDO)

歴史あるものの魅力を再確認

イギリス軍の防水型軍用コートとして第一次世界大戦時に生まれ、誕生当時の原形をほとんど変えず今なお第一線。とことんベーシックに忠実なアイテムだからこそ、あらゆるシーンでオシャレを委ねることができます。オーセンティックなデザインと質にこだわった本物の1枚を手にし、極めることでオシャレが激的に広がりを見せます。

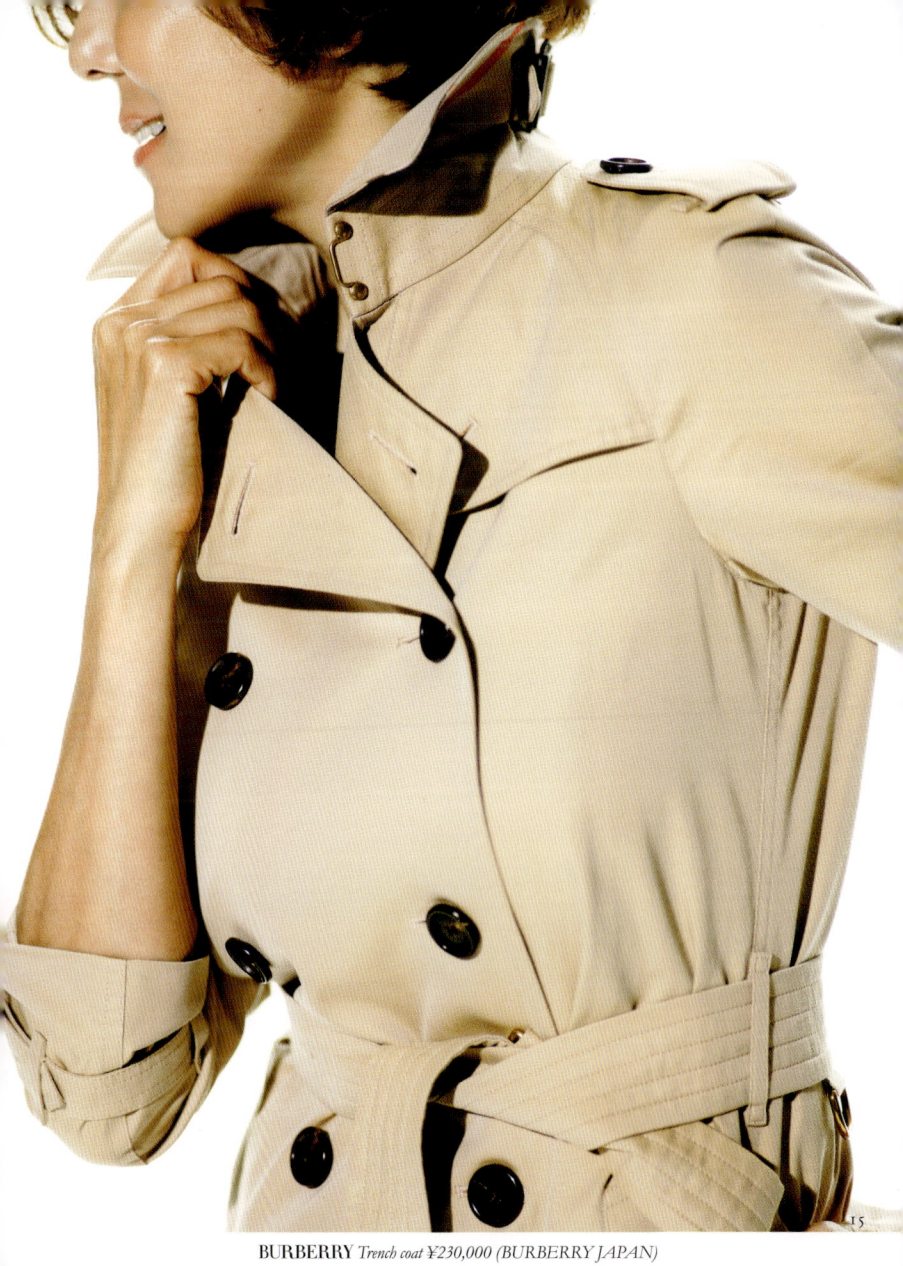

BURBERRY *Trench coat* ¥230,000 (BURBERRY JAPAN)

BURBERRY *Trench coat* ¥230,000
(BURBERRY JAPAN)
RIKA BY ULRIKA LUNDGREN
T-shirt ¥15,000 *Skirt* ¥37,000 *(UNIT GUEST)*
Christian Louboutin *Pumps* ¥119,000
(Christian Louboutin Japan)
Cartier *Watch* ¥2,010,000 *(Cartier)*
Bag *RIKACO'S OWN

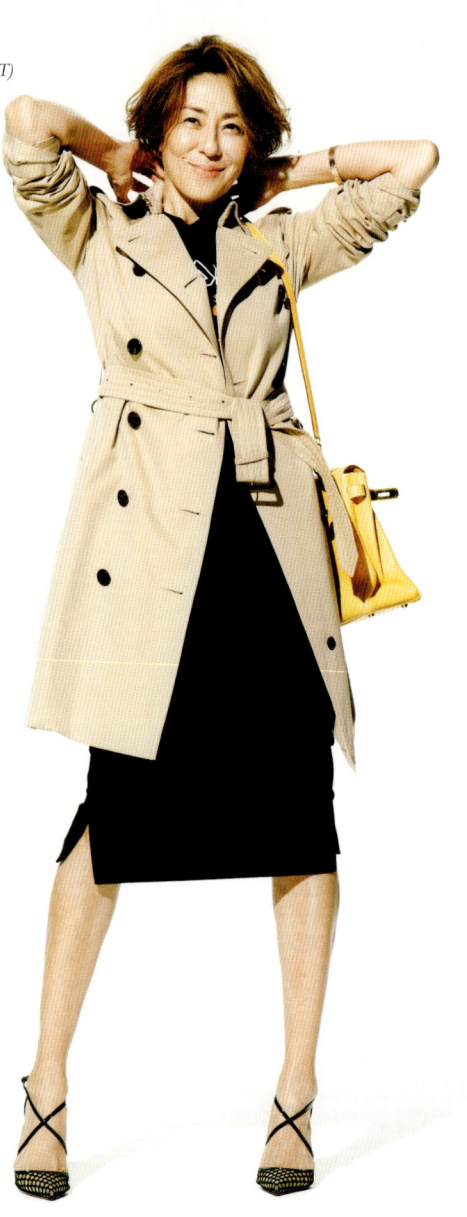

BURBERRY *Trench coat ¥230,000*
(BURBERRY JAPAN)
DRAWER *Sweat shirt ¥17,000*
(DRAWER AOYAMA)
RALPH LAUREN COLLECTION
Leather pants ¥263,000 (RALPH LAUREN)
RALPH LAUREN
Bag ¥210,000 (RALPH LAUREN)
*Sneakers, Pierced earrings *RIKACO'S OWN*

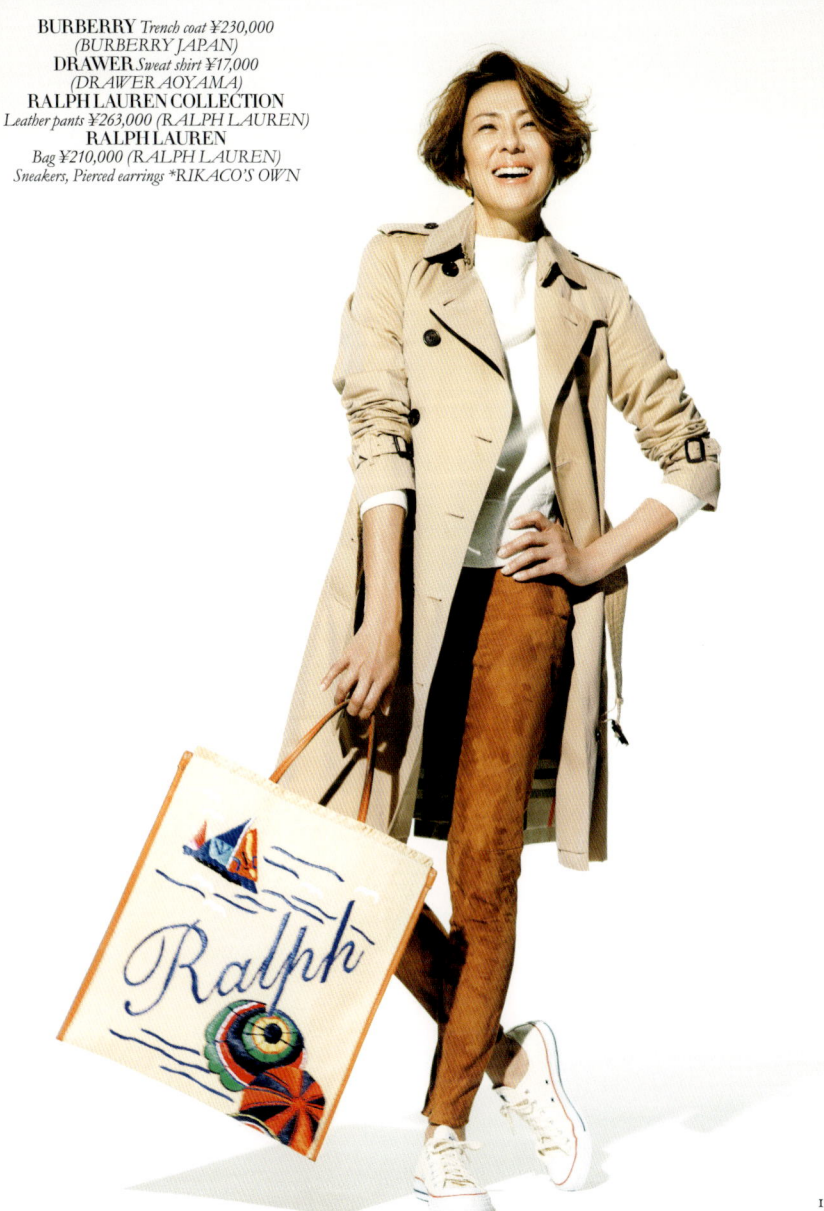

BURBERRY *Trench coat* ¥230,000
(BURBERRY JAPAN)
Champion *T-shirt* ¥5,900 *(HanesBrands Japan)*
ZARA *Skirt* ¥4,990 *(ZARA JAPAN)*
adidas Originals *Sneakers* ¥14,000
(adidas group customer service)
L.L.Bean *Bag* ¥3,900 *(L.L.Bean customer servicecenter)*
Socks *RIKACO'S OWN

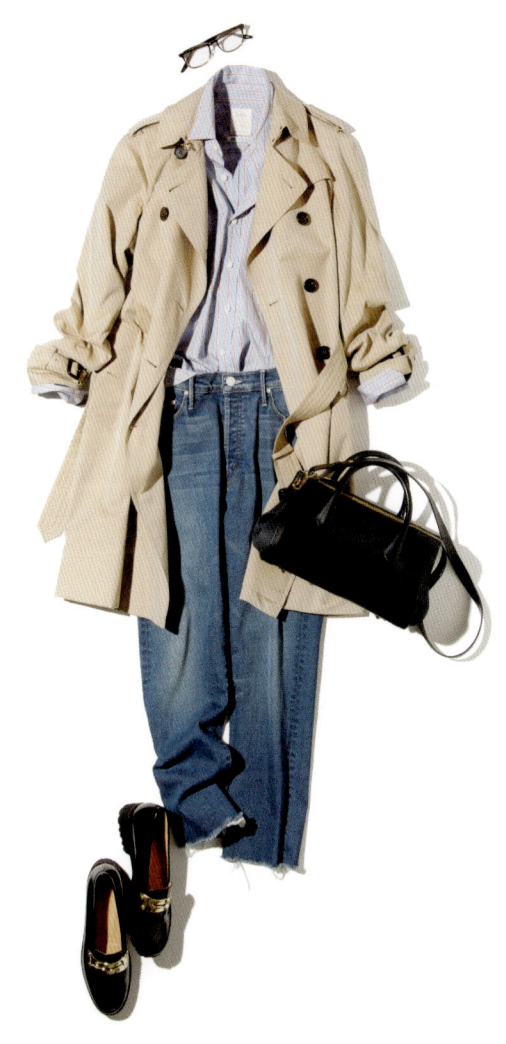

BURBERRY *Trench coat* ¥230,000 (BURBERRY JAPAN)
JOURNAL STANDARD L'ESSAGE *Shirt* ¥14,000
(JOURNAL STANDARD L'ESSAGE GINZA)
MOTHER *Denim pants* ¥34,000 (The SAZABY LEAGUE)
UNITED ARROWS *Shoes* ¥22,000 (UNITED ARROWS HARAJUKU FOR WOMEN)
GLOBE-TROTTER *Bag* ¥195,000
(GLOBE-TROTTER GINZA)
BARTON PERREIRA *Glasses* ¥40,000 (Lieto)

BIKER JACKET

女性らしい艶を表すアイテム

リーバイス同様10代で出合って今なお愛してやまないのがライダース。そのコレクションも今や相当数。武骨でハードなアイテムだからこそ生まれるハレーションがこれみよがしでない女性らしい佇まいを生みます。確実に攻めのワードローブだから残された部分はベーシックに。仕上げを担うのは着こなしの絶妙なディテールです。

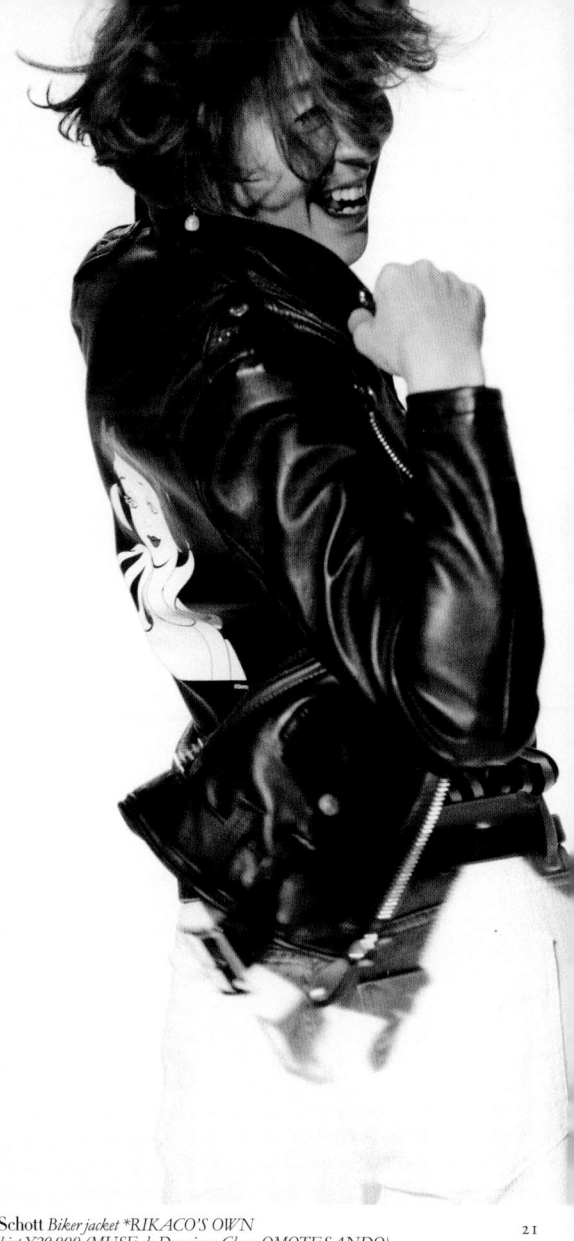

Schott *Biker jacket *RIKACO'S OWN*
Deuxieme Classe *Shirt ¥29,000 (MUSE de Deuxieme Classe OMOTESANDO)*
ZARA *Pants ¥4,990 (ZARA JAPAN)*, Scye *Belt ¥26,000 (Masterpiece showroom), Pierced earrings *RIKACO'S OWN*

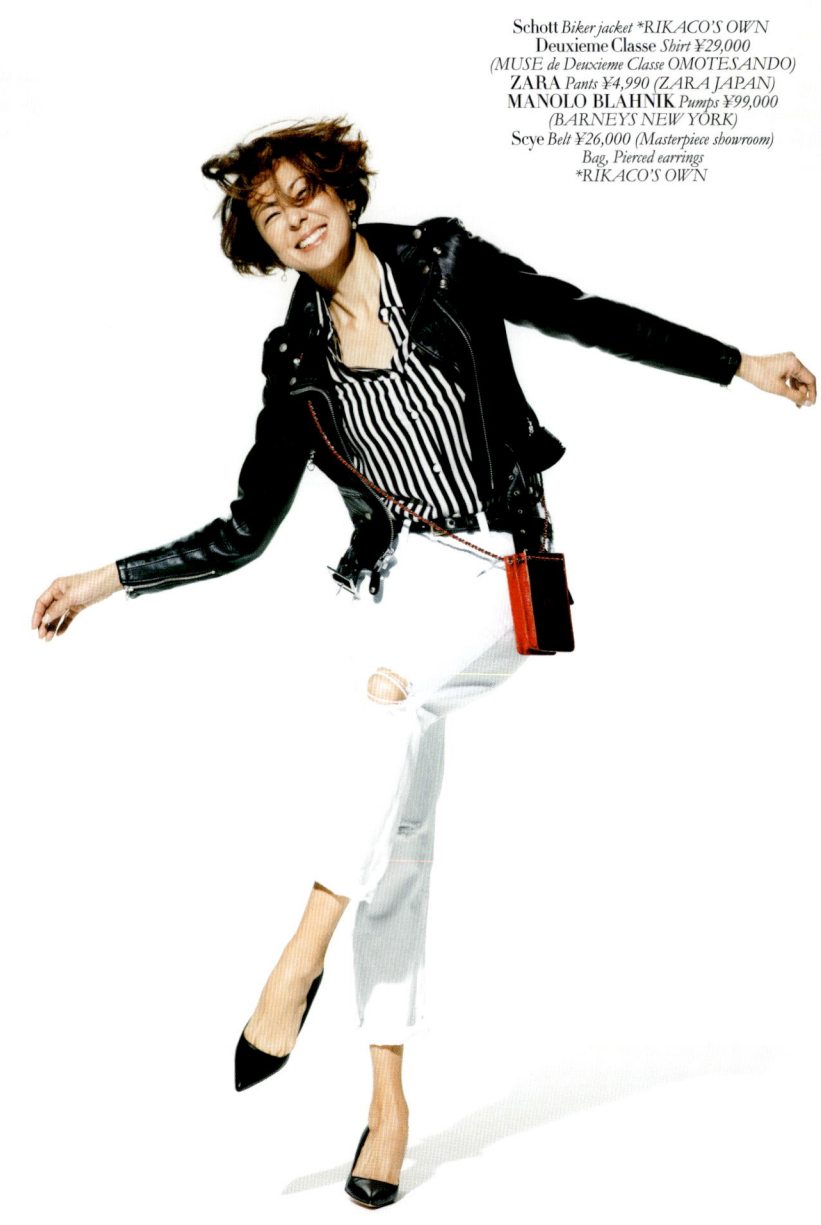

Schott *Biker jacket* *RIKACO'S OWN
Deuxieme Classe *Shirt* ¥29,000
(MUSE de Deuxieme Classe OMOTESANDO)
ZARA *Pants* ¥4,990 *(ZARA JAPAN)*
MANOLO BLAHNIK *Pumps* ¥99,000
(BARNEYS NEW YORK)
Scye *Belt* ¥26,000 *(Masterpiece showroom)*
Bag, Pierced earrings
**RIKACO'S OWN*

Acne *Biker jacket* *RIKACO'S OWN*
adidas Originals *Sneakers* ¥14,000
(adidas group customer service)
ayame *Glasses* ¥30,000 *(blinc vase)*
Pocket *Bangle* ¥26,800 *(Pocket)*
T-shirts, Pants, Bag *RIKACO'S OWN*

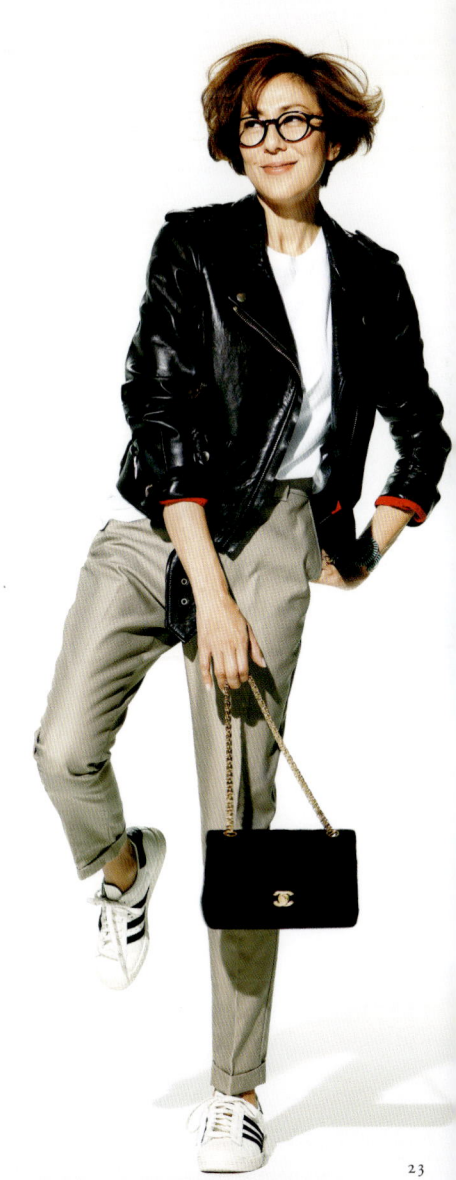

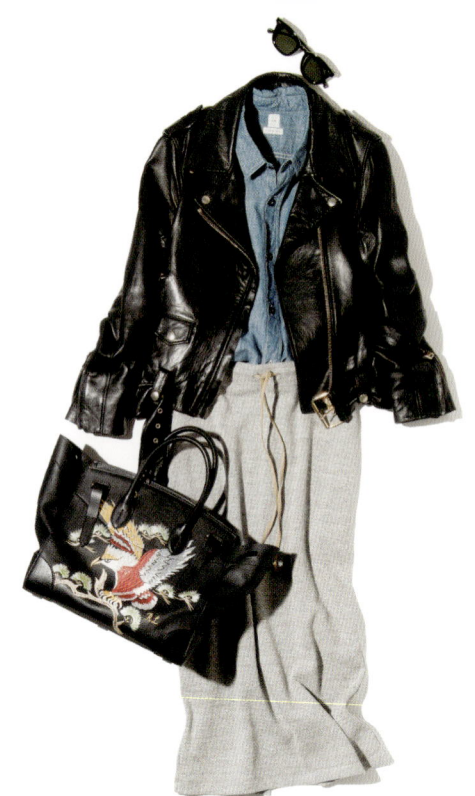

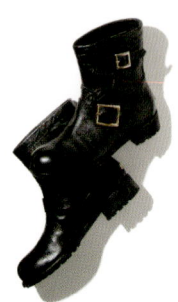

Acne *Biker jacket* *RIKACO'S OWN*
SEA *Shirt* ¥25,000 *(S-STORE)*
UNITED ARROWS *Sweat skirt* ¥12,000
(UNITED ARROWS HARAJUKU FOR WOMEN)
JIMMY CHOO *Boots* ¥117,000 *(JIMMY CHOO)*
MAX PITTON *Sunglasses* ¥39,000 *(the LIGHT)*
RALPH LAUREN
Bag *RIKACO'S OWN*

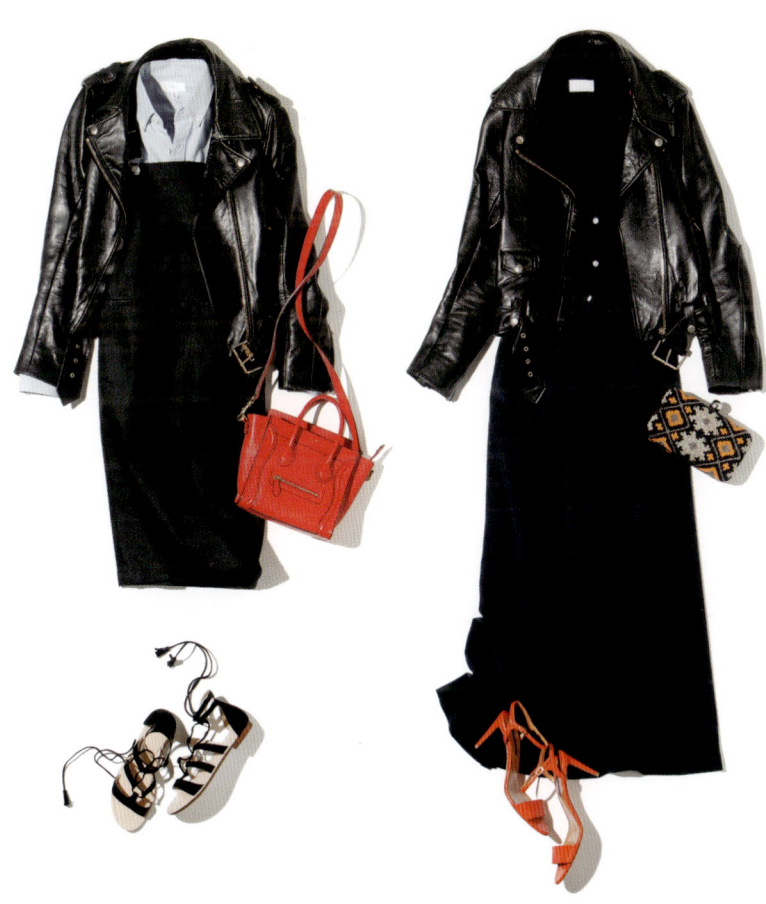

Acne *Biker jacket* *RIKACO'S OWN
MACPHEE *Overall skirt* ¥16,000,
TOMORROWLAND
Sandals ¥16,000
(TOMORROWLAND)
Shirt, Bag *RIKACO'S OWN

Acne *Biker jacket* *RIKACO'S OWN
haunt *One-piece* ¥36,000
(hauntDAIKANYAMA)
RALPH LAUREN
Pumps *Reference item
(RALPH LAUREN)
SANTI *Bag* ¥18,000
(UNITED ARROWS HARAJUKU FOR WOMEN)

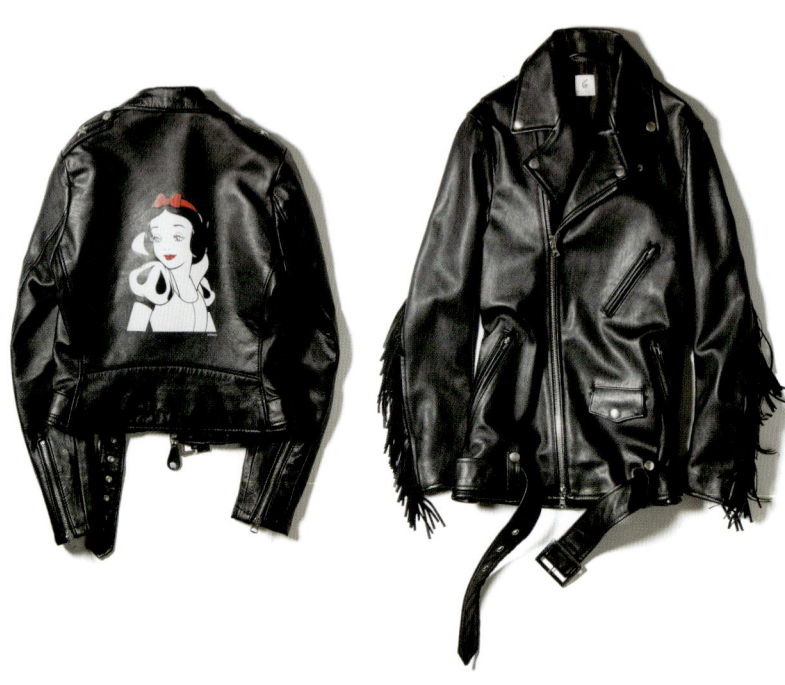

Schott
RIKACO'S OWN

BEAUTY AND YOUTH UNITED ARROWS
RIKACO'S OWN

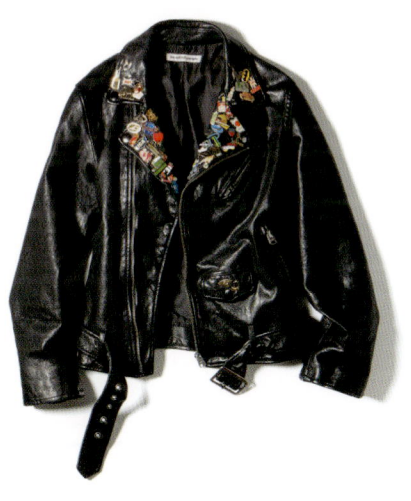
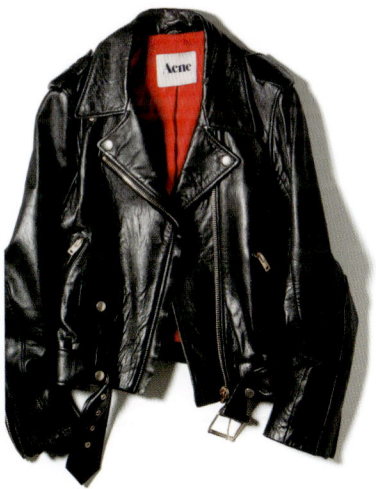

beautiful people
*RIKACO'S OWN

Acne
*RIKACO'S OWN

BLAZER

もはやDNA的なトラッドもの

ジャケットに袖を通したときの凛とした感覚が好き。でも品行方正なだけに、ただ普通に着ただけでは垢抜けない。鏡の前であれやこれやと試行錯誤して着くずす。このプロセスがあってこそ手に入る「無造作感」が必須。ジャケットはラペルが細め、キレイなショルダーラインのシングルボタンがいろいろなベクトルで着回せます。

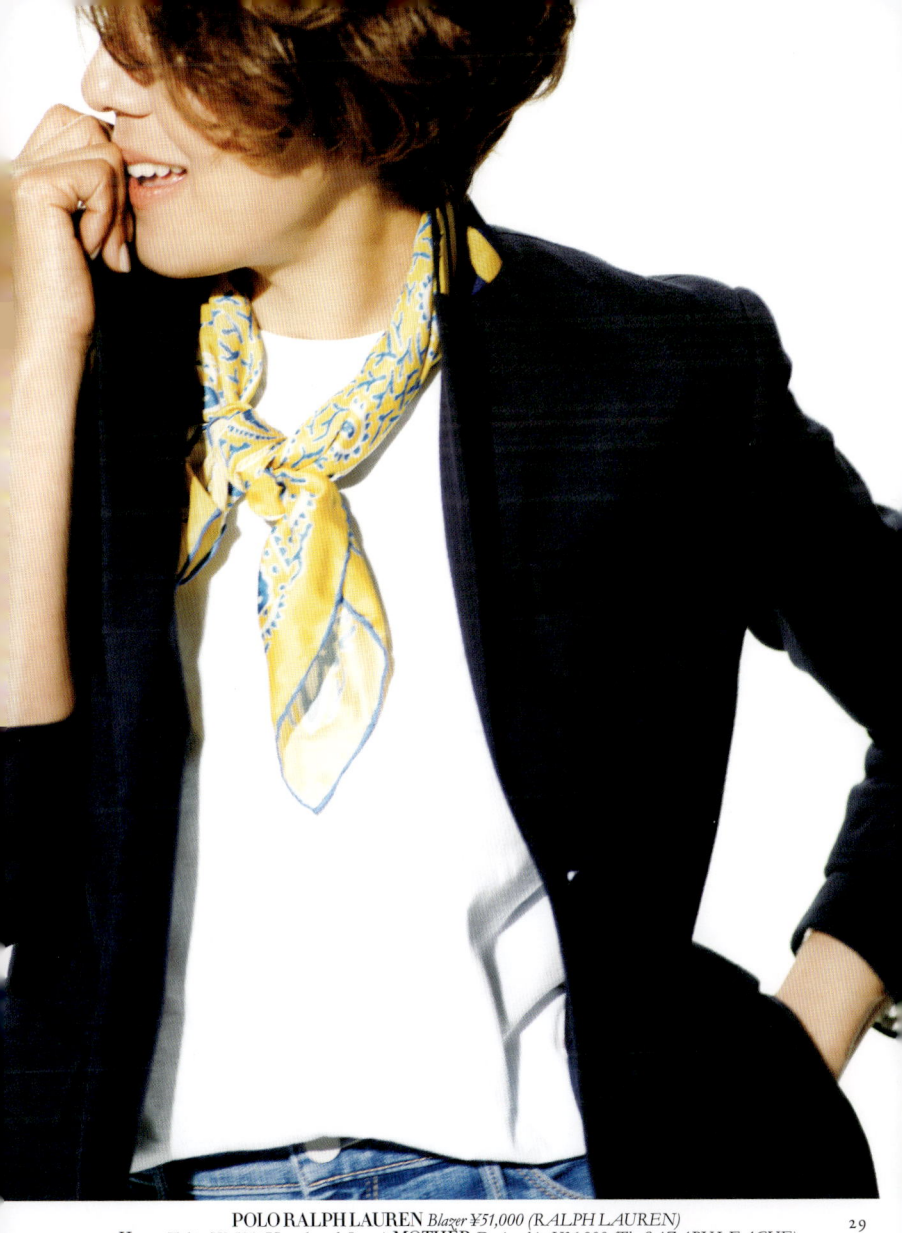

POLO RALPH LAUREN *Blazer* ¥51,000 (RALPH LAUREN)
Hanes *T-shirt* ¥2,500 (Hanesbrands Japan), MOTHER *Denim skirt* ¥36,000 (The SAZABY LEAGUE)
FIORIO *Scarf* ¥12,000 (UNITED ARROWS HARAJUKU FOR WOMEN)

POLO RALPH LAUREN
Blazer ¥51,000 *(RALPH LAUREN)*
Hanes *T-shirt* ¥2,500 *(Hanesbrands Japan)*
MOTHER *Denim skirt* ¥36,000
(The SAZABY LEAGUE)
FIORIO *Scarf* ¥12,000
*(UNITED ARROWS HARAJUKU
FOR WOMEN)*
Bag, Bangle *RIKACO'S OWN

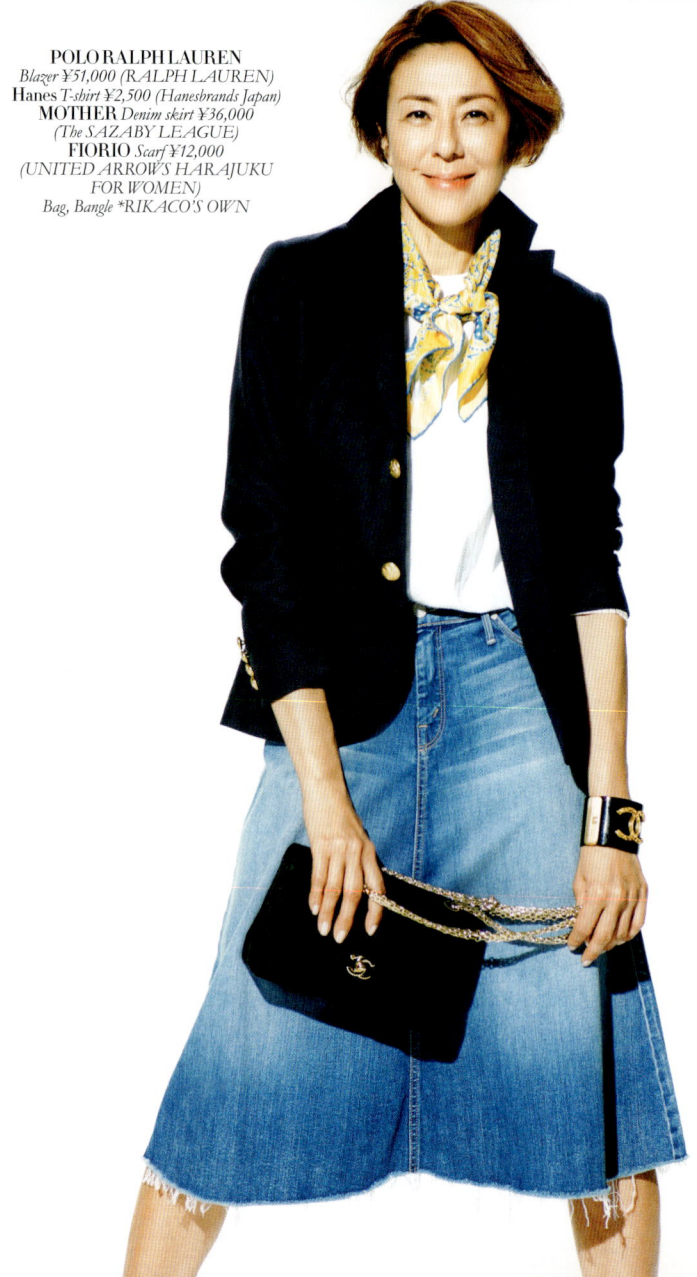

POLO RALPH LAUREN
Blazer ¥51,000 (RALPH LAUREN)
ORIAN *Shirt ¥21,000*
(JOURNAL STANDARD
L'ESSAGE GINZA)
ARATA *Sweat pants ¥27,000*
(INTERLIB INC.)
NEBULONIE *Pumps ¥44,000*
(URBAN RESEARCH ROSSO
LUMINE YURAKUCHO)
*Bag, Watch *RIKACO'S OWN*

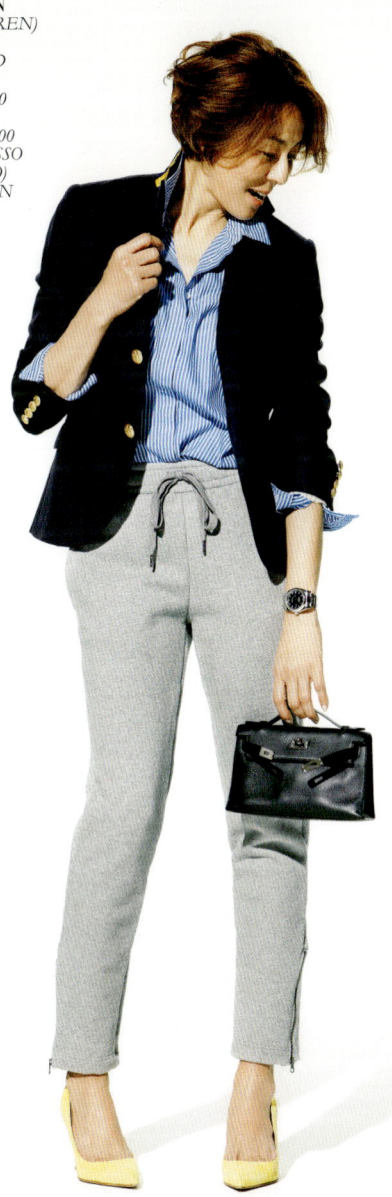

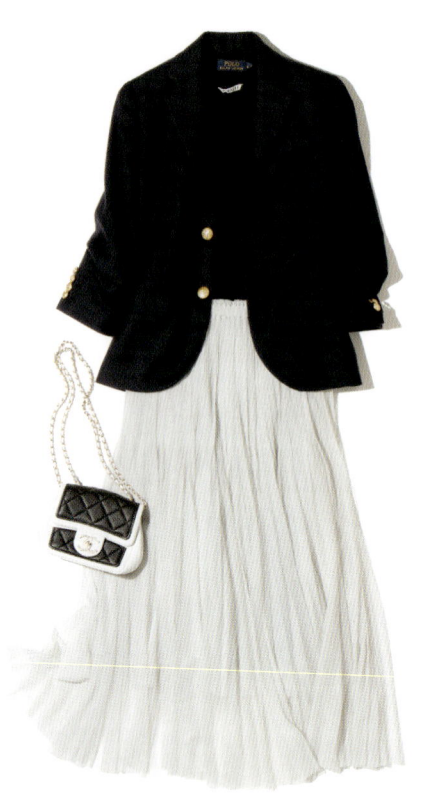

POLO RALPH LAUREN *Blazer* ¥51,000
(RALPH LAUREN)
AURALEE *T-shirt* ¥6,800 (Bshop)
TOMMOROWLAND *Skirt* ¥18,000
(TOMORROWLAND)
La TENACE *Pumps* ¥12,000 (NDC JAPAN)
Bag *RIKACO'S OWN

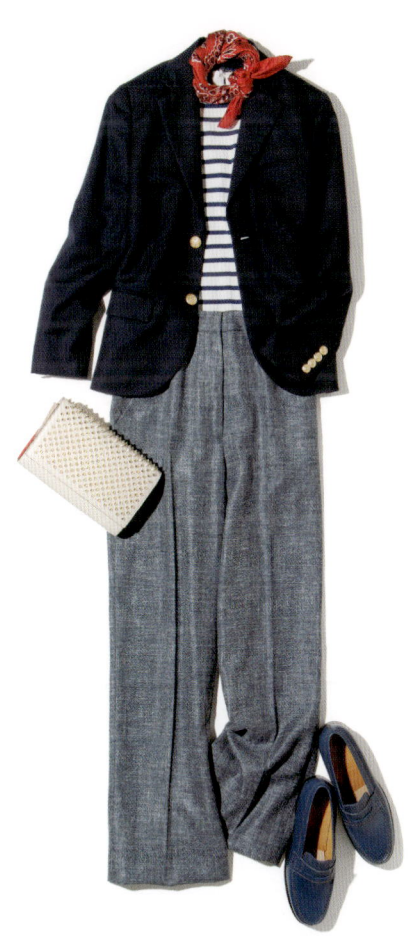

POLO RALPH LAUREN *Blazer* ¥51,000 (RALPH LAUREN)
ARATA *Top* ¥19,000(ARATA/INTERLIB INC.)
PROTAGONIST *Pants* ¥86,000
(JOURNAL STANDARD L'ESSAGE GINZA)
J.M. WESTON *Shoes* ¥141,000*Order Price
(J.M. WESTON AOYAMA)
Christian Louboutian *Bag* ¥149,000 (Christian Louboutian Japan)
MANIPULI *Scarf* ¥7,800 (journal standard L'essage GINZA)

カジュアルだからこそパール

異なるテイストをかけ合わせたときに起こるノイズが楽しめる無二のジュエリー。独特な色と艶が肌と馴染んでコーディネートにニュアンスを生みます。100cmのロングパールを基本に最近ではTASAKIのタクーン・パニクガルがデザインする「バランス」や「リファインド リベリオン」などエッジの利いたシリーズも集めています。

M/G TASAKI *Earrings* ¥620,000 *Ring* ¥264,000 *(TASAKI)*, **ENES** *Top* ¥84,000 *(Whim Gazette Aoyama)*

TIFFANY *Necklace* *RIKACO'S OWN
1961 BY FRED SEGAL *T-shirt* ¥7,000 (Fred Segal)
Wrangler×SENSE OF PLACE *Pants* ¥5,900
(SENSE OF PLACE by URBAN RESEACH
QPLAZA HARAJUKU)
MAISON BOINET *Belt* ¥25,000
(EN ROUT GINZA)
Christian Louboutian *Pumps* ¥89,000
(Christian Louboutian Japan)
Biker jacket *RIKACO'S OWN

TIFFANY *Necklace *RIKACO'S OWN*
RALPH LAUREN COLLECTION
Knitwear ¥87,000 (RALPH LAUREN)
JOURNAL STANDARD *Pants ¥13,000*
(JOURNAL STANDARD OMOTESANDO)
*Sneakers, Bag, Watch *RIKACO'S OWN*

TIFFANY *Necklace *RIKACO'S OWN*
haunt *Shirt ¥26,000 (haunt DAIKANYAMA)*
RE/DONE *Denim pants ¥46,000 (Fred Segal)*
BIRKENSTOCK *Sandals ¥11,000*
(BIRKENSTOCK SHINJUKU)
*Bag *RIKACO'S OWN*

TIFFANY *Necklace *RIKACO'S OWN*
ENES *Top ¥84,000 (Whim Gazette Aoyama)*
JOURNAL STANDARD L'ESSAGE *Pants ¥19,000*
(JOURNAL STANDARD L'ESSAGE GINZA)
MANIPURI *Bangle ¥16,000*
(AMERICAN RAG CIE SHIBUYA)
*Sneakers, Bag *RIKACO'S OWN*

TIFFANY
*RIKACO'S OWN
(TIFFANY&Co.)*

TASAKI
Necklace ¥396,000
Pierced earrings ¥340,000
(TASAKI)

M/G TASAKI
Necklace ¥360,000
(TASAKI)

KNIT WEAR

肌の一部化したカシミアが好き

私にとって、子どもの頃父の膝の上で頬に感じた柔らかさをデジャヴのように彷彿させるのがカシミアのニット。素材の心地よさもさることながら、シンプルで時代を問わないアイテムなのに、着こなし次第でその人の雰囲気が生まれる。そこにベーシックの底力を感じます。目指すは極めてベーシックなのに印象に残るスタイリング。

RALPH LAUREN COLLECTION *Knitwear* ¥87,000 *(RALPH LAUREN)*
BACCA *Pants* ¥18,000 *(Edition OMOTESANDOHILLS)*
PHILIPPE AUDIBERT *Pierced earrings* ¥11,000 *(STRASBURGO)*
John Renner for AMERICAN RAG CIE *Bangle[top(turquoise)]* ¥35,000 *(AMERICAN RAG CIE SHIBUYA)*
ORVILLE TSINNIE×BEAMS BOY *Bangle[middle]* ¥58,000 *Bangle[bottom(plain)]* ¥42,000 *(BEAMS BOY HARAJUKU)*

RALPH LAUREN COLLECTION
Knitwear ¥87,000 *(RALPH LAUREN)*
BACCA *Pants* ¥18,000
(Edition OMOTESANDO HILLS)
RALPH LAUREN *Bag* ¥390,000
(RALPH LAUREN)
PHILIPPE AUDIBERT
Pierced earrings ¥11,000 *(STRASBURGO)*
John Renner for AMERICAN RAG CIE
Bangle[top(turquoise)] ¥35,000
(AMERICAN RAG CIE SHIBUYA)
ORVILLE TSINNIE×BEAMS BOY
Bangle[middle] ¥58,000
Bangle[bottom(plain)] ¥42,000
(BEAMS BOY HARAJUKU)
Sneakers *RIKACO'S OWN*

JOHNSTONS
Knitwear ¥70,000 (Lea mills agency)
Steven Alan *Shirt *RIKACO'S OWN*
Mila Owen *Skirt ¥12,000 *setup price*
(Mila Owen LUMINE Shinjuku2)
TOMORROWLAND *Shoes ¥54,000*
(TOMORROWLAND)
SMYTHSON *Wallet ¥95,000*
(VULCANIZE London)
TIFFANY *Watch ¥850,000*
(TIFFANY&Co.)
Links of London *Pierced earrings ¥175,000*
(Links of London Aoyama)
*Socks *RIKACO'S OWN*

JOSEPH *Knitwear* *RIKACO'S OWN*
6 *Pants* ¥21,000
(ROKU BEAUTY&YOUTH SHINJUKU)
adidas Originals
Sneakers ¥14,000 *(adidas group customer service)*
Bag *RIKACO'S OWN*

EQUIOMENT *Turtleneck Sweater* ¥43,000
(The SAZABY LEAGUE)
DEMYLEE *Denim coat* ¥32,000 *(The SAZABY LEAGUE)*
ZARA *Skirt* ¥4,990*(ZARA JAPAN)*
PIPPICHIC *Sandals* ¥32,000
(UNITED ARROWS HARAJUKU FOR WOMEN)
Christian Louboutian *Bag* ¥149,000
(Christian Louboutian Japan)
MAX PITTION *Sunglasses* ¥39,000 *(the LIGHT)*

Cruciani *Knit cardigan* ¥98,000
Knit top ¥69,000 *(STRASBURGO)*
RIKA BY ULRIKA LUNDGREN
Skirt ¥37,000 *(UNIT & GUEST)*
BAGMATI *Bag* ¥13,000
(JOURNAL STANDARD L'ESSAGE GINZA)
Boots *RIKACO'S OWN

M.MARTIN
¥75,000
(MUSE de Deuxieme Classe Omotesando)

Cruciani
¥140,000
(Cruciani Ginza)

VINCE.
¥61,000
(VINCE OMOTESANDO)

JOSEPH
*RIKACO'S OWN

DUFFLE COAT

懐かしいけど新たなバランスで

紺ブレ同様私のDNAに流れているトラッドの代表格的なアイテムだけど、経験値も上がった今、カテゴライズを曖昧にしてミックスする発想の転換がオシャレの進化に繋がります。永久不滅のベーシックは存在しません。ダッフルコート自体は原形に忠実なデザインを選び、丈が少し長めのものを選ぶとボトムスのチョイスが広がります。

*Duffle coat *RIKACO'S OWN*

Duffle coat *RIKACO'S OWN
Bilitis dix-sept ans *T-shirt ¥15,000 (Bilitis)*
JANE SMITH *Denim pants ¥17,000 (HEMT PR)*
OLIVER PEOPLES *Glasses ¥30,000*
(OLIVER PEOPLES TOKYO GALLERY)
Sneakers, Bag, Watch *RIKACO'S OWN

Duffle coat *RIKACO'S OWN
THE SHIRT by upper hights
Shirt ¥26,000 (GUEST LIST)
Bilitis dix-sept ans *Skirt* ¥38,000 (Bilitis)
Pumps, Bag, Pierced earrings, Bangle
*RIKACO'S OWN

53

Duffle coat *RIKACO'S OWN*
Hanes *Thermal T-shirt ¥1,800 (Hanesbrands Japan)*
SEA *Skirt ¥26,000 (S-STORE)*
JIMMY CHOO
Boots ¥121,000 (JIMMY CHOO)
*Sweat parka, Bag *RIKACO'S OWN*

Duffle coat *RIKACO'S OWN
G-Star RAW *Overalls* ¥50,000
(G-Star International)
Deuxieme Classe *Shirt* ¥20,000
(MUSE de Deuxieme Classe OMOTESANDO)
NEBULONIE *Pumps* ¥44,000
(URBAN RESEARCH ROSSO LUMINE YURAKUCHO)
Bag *RIKACO'S OWN

TURQUOISE

アイデンティティ的ジュエリー

私にとっての宝物はラルフ・ローレン氏直々に頂いた4連のネックレス。かなりのボリュームで存在感もあるのですが私らしさを託せるジュエリーとして愛用しています。カジュアルには定番ですが、洗練されたキレイめスタイルのはずしアイテムとしても有効です。色遊びもできパールとはまた違った魅力でオシャレにコクをだします。

Necklace *RIKACO'S OWN, **Pocket** *Ring ¥22,000 (Pocket),* **SEA** *Shirt ¥25,000 (S-STORE)*

Necklace *RIKACO'S OWN
Pocket *Ring* ¥22,000 (Pocket)
SEA *Shirt* ¥25,000 (S-STORE)
Deuxieme Classe *Pants* ¥91,000
(MUSE de Deuxieme Classe OMOTESANDO)
Scye *Belt* ¥12,000 (Masterpiece showroom)

Necklace *RIKACO'S OWN
Deuxieme Classe *Long coat* ¥20,000, *Top* ¥19,000
(MUSE de Deuxieme Classe OMOTESANDO)
superfine *Pants* ¥23,000 *(VULCANIZE London)*
MANOLO BLAHNIK *Pumps* ¥99,000
(BARNEYS NEW YORK)
NORTH WORKS *Bangle* ¥30,000 *(HEMT PR)*
Bag *RIKACO'S OWN

Kong qi *Necklace ¥35,000*
(Balata concierge Press Room)
JOURNAL STANDARD *Skirt ¥14,000*
(JOURNAL STANDARD OOTESANDO)
*Blouson, Top, Sneakers, Bag *RIKACO'S OWN*

Pocket *Bangle(left hand)* ¥26,800
Ring ¥22,000 *(Pocket)*
NORTH WORKS
Bangle(right hand(turquoise)) ¥20,000
(right hand(silver)) ¥30,000 *(HEMT PR)*
JAMES PERSE *T-sihrt* ¥11,000
(JAMES PERSE AOYAMA)
RED CARD *Denim pants*
¥19,000 *(GUEST LIST)*
AMERICAN RAG CIE *Bag* ¥8,500
(AMERICAN RAG CIE SHIBUYA)
Sleeveless top *RIKACO'S OWN

Necklace
RIKACO'S OWN

Kongqi
Necklace ¥35,000
(Balata concierge Press Room)
NORTH WORKS
Bangle[top] ¥20,000
(HEMT PR)
Pocket
Bangle[bottom] ¥26,800 Ring ¥22,000
(Pocket)
Shumu
Bracelet ¥15,000
(Balata concierge Press Room)

SNEAKERS

オールドスクールユーザーです

日本の風潮として年齢を重ねると落ち着いたスタイルが当然みたいなところがあるけれど、オシャレは大切な自己表現だから私的にはスニーカーはこれからもずっと履き続けたいな。端正すぎるオシャレのバランスをくずすときも一役買ってくれるし、コンバースが履きたいからこの服というときもあるくらい愛着の深いアイテムです。

adidas Originals‹Stan Smith› *Sneakers *RIKACO'S OWN*, **MACPHEE** *Pants ¥13,000 (TOMORROWLAND)*

adidas Originals ‹Stan Smith›
*Sneakers *RIKACO'S OWN*
MACPHEE *Pants ¥13,000*
(TOMORROWLAND)
*Jacket, Top, Bangles *RIKACO'S OWN*

COVERSE <All Star>
*Sneakers *RIKACO'S OWN*
SEA *Denim jacket* ¥32,000 (S-STORE)
Deuxieme Classe *Shirt* ¥20,000
(MUSE de Deuxieme Classe OMOTESANDO)
RED CARD *Denim Skirt*
¥19,000 (GUEST LIST)
Bag, Watch, Pierced earrings
**RIKACO'S OWN*

adidas Originals<Stan Smith>
Sneakers ¥14,000 (adidas group customer service)
Deuxieme Classe *Pants ¥20,000*
(MUSE de Deuxieme Classe OMOTESANDO)
SANTI *Bag ¥18,000*
(UNITED ARROWS HARAJUKU FOR WOMEN)
OLIVER PEOPLES *Glasses ¥30,000*
(OLIVER PEOPLES TOKYO GALLERY)
*Shirt *RIKACO'S OWN*

CONVERSE ‹All Star›
*Sneakers *RIKACO'S OWN*
POLO RALPH LAUREN *Cardigan ¥68,000*
Shirt ¥15,000 (RALPH LAUREN)
Fred Segal *Sweat pants ¥16,000 (Fred Segal)*
*Bag *RIKACO'S OWN*

adidas Originals⟨SUPERSTAR⟩
¥14,000
(adidas group customer service)

NIKE⟨FREE 5.0⟩
*RIKACO'S OWN

VANS‹AUTHENTIC›
¥4,500
(VANS JAPAN)

Admiral‹GREENPARK›
¥11,800
(Sojitz GMC)

PUMPS

気分が高揚する魔法のアイテム

「女に生まれてよかった…」と思う瞬間。そしてルーティンから引っ張りだし、いつもと違う女性像を連れてきてくれる瞬間。足を入れたときに背筋の伸びる感じが自信に繋がるのかな。ちょっと武骨さを感じるくらいのスタイリングにパンプスをプラスするとテンションまで上がるから不思議。足指の付け根がのぞく靴が好みです。

JIMMY CHOO *Pumps* ¥74,000 *(JIMMY CHOO)*
THE NEW HOUSE *Sleeveless top* ¥15,000 *(ROKU BEAUTY&YOUTH SHINJUKU)*
Levi's® *Denim pants *Vintage* ¥59,800 *(BerBerJin),* **Hirotaka** *Ring [left hand, ring finger]* ¥62,000
Ring[left hand, middle finger and little finger / right hand, little finger] each ¥13,000 *(showroom SESSION)*

73

JIMMY CHOO *Pumps ¥74,000 (JIMMY CHOO)*
BURBERRY *Trench coat ¥230,000 (BURBERRY JAPAN)*
THE NEW HOUSE *Sleeveless top ¥15,000 (BEAUTY&YOUTH UNITED ARROWS)*
Levi's® *Denim pants *Vintage*
*Pierced earrings *RIKACO'S OWN*

[top to bottom]
JIMMY CHOO
¥123,000
(JIMMY CHOO)
PELLICO
¥46,000
(PELLICO)
Christian Louboutin
¥89,000
(Christian Louboutin Japan)
GIANVITO ROSSI
¥73,000
(TOMORROWLAND)

ENGINEER BOOTS

何年もかけ、足に馴染ませるもの

年齢を重ねても目指す女性像は同じ。するとワードローブもどんどん研ぎ澄まされ精鋭だけが残る。結局10代の頃から好きなものは何ひとつ変わっていない。これから10年先もこのエンジニアブーツが履きこなせる自分でありたいと思ってシュークローゼットに10代からずっとあるファーストエンジニア、これからもずっと一緒。

JIMMY CHOO Boots ¥117,000 (JIMMY CHOO)
JAMES PERSE One-piece ¥45,000 (JAMES PERSE AOYAMA) Blouson, Bangle *RIKACO'S OWN

JIMMY CHOO
Boots ¥117,000 (JIMMY CHOO)
JAMES PERSE *One-piece ¥45,000*
(JAMES PERSE AOYAMA)
MUUN *Bag ¥18,800 (Bshop)*
*Blouson, Bangle *RIKACO'S OWN*

JIMMY CHOO
¥117,000
(JIMMY CHOO)

BUTTERO
¥72,000
(HIGH BRIDGE INTERNATIONAL)

T-SHIRT

なくてはならないものの筆頭

冬のカシミア、夏のTシャツはトップスとして欠くことができないもの。そして奥が深いもの。首周りの絶妙なバランス、素材の落ち感、袖や着丈の長さ、ちょっとしたスペックの差でまったくの別物になります。究極のシンプルアイテムだからこそ、自分らしいプラスアルファなあしらいが個性となりその人の印象をつくります。

MACPHEE *T-shirt ¥6,200(MACPHEE)*, **JANE SMITH** *Bandanna ¥4,500 (HEMT PR)*
STETSON *Hat ¥33,000 (STETSON JAPAN)*, **TIFFANY** *Bangle ¥60,000 (TIFFANY&Co.)*

RIKA BY ULRIKA LUNDGREN
T-shirt ¥15,000 (UNIT&GUEST)
DRESSTERIOR *Jacket ¥33,000*
(DRESSTERIOR SHINJYUKU)
Christian Louboutin *Pumps ¥129,000*
(Christian Louboutin Japan)
Denim pants, Bangle
*RIKACO'S OWN

MACPHEE *T-shirt ¥6,200*
(TOMORROWLAND)
BACCA *Pants ¥18,000*
(Edition OMOTESANDOHILLS)
AQUAZZURA *Pumps ¥78,000*
(TOMORROWLAND)
JANE SMITH *Bandanna ¥4,500(HEMT PR)*
COCOSHNIK *Pierced earrings ¥28,000*
(COCOSHNIK)
a.v.max *Bangle ¥8,500*
(COCOSHNIK ONKITSCH
YURAKUCHOMARUI)
*Bag *RIKACO'S OWN*

Champion *T-shirt ¥6,900*
(Hanesbrands Japan)
POLO RALPH LAUREN
Leather pants ¥137,000 (RALPH LAUREN)
Admiral *Sneakers ¥11,800 (Sojitz GMC)*
MIRIAM HASKELL
Necklace ¥42,000 (TOMORROWLAND)
*Bag, Scarf *RIKACO'S OWN*

Hanes *Thermal T-shirts* ¥1,800 *(Hanesbrands Japan)*
6 *Skirt* *RIKACO'S OWN
Kongqi *Necklace* ¥37,000
(Balata concierge Press Room)
NORTH WORKS
Bangle[top] ¥30,000
[bottom(turquoise)] ¥20,000 *(HEMT PR)*
Bag *RIKACO'S OWN

Hanes
¥1,500
(Hanesbrands Japan)

JAMES PERSE
¥29,000
(JAMES PERSE AOYAMA)

SAINT JAMES
¥12,800
(MUSE de Deuxieme Classe OMOTESANDO)

LE MINOR
¥11,000
(GALERIE VIE MARUNOUCHI)

Happiness
¥7,000
(GUEST LIST)

MIXTA×JOURNAL STANDARD L'ESSAGE
¥7,200
(JOURNAL STANDARD L'ESSAGE GINZA)

JAMES PERSE
¥15,000
(JAMES PERSE AOYAMA)

THE NEW HOUSE
Sleeveless top ¥15,000
(BEAUTY&YOUTH UNITED ARROWS)

SHIRT

無造作をキーワードに着る

シャツ自体はエターナルだけれど、そのシルエットは少しずつ変化をしています。錆びないための更新作業はマメにすることが必要。胸元のボタンはいくつ開けるか、袖をどうあしらうか、シャツは着こなし次第でいくらでも雄弁なアイテムになり得ます。白シャツ、ストライプ、ダンガリーを基軸に素材に変化をつけて買い揃えています。

Shirt *RIKACO'S OWN, **TIFFANY** *Pierced earrings ¥958,000 (TIFFANY&Co.)*

Shirt *RIKACO'S OWN
shakuhachi Skirt ¥38,000
(Whim Gazette Aoyama)
BURBERRY Boots ¥100,000
(BURBERRY JAPAN)
TIFFANY Watch ¥850,000
Pierced earrings ¥958,000
(TIFFANY&Co.)
Necklace, Socks
*RIKACO'S OWN

ORIAN *Shirt* ¥19,000
(YAGI TSUSHO)
Wrangler for RomHerman
Denim pants
**RIKACO'S OWN*
FABIO RUSCONI
Pumps ¥23,000
(FABIO RUSCONI
ROPPONGI)
MUUN
Bag ¥18,800 (Bshop)
*Watch *RIKACO'S OWN*

GARCONS INFIDELES
Shirt ¥34,000
(DRESSTERIOR SHINJUKU)
ZARA *Denim jacket* ¥9,990
(ZARA JAPAN)
Bilitis dix-sept ans
Skirt ¥38,000 *(Bilitis)*
Amb *Sneakers* ¥22,000
(HIGH BRIDGE INTERNATIONAL)
Bangle *RIKACO'S OWN*

Serra Retreat
Shirt ¥22,000 (GUESTLIST)
NOIR DE MUSE *Pants ¥20,000*
(MUSE de Deuxieme Classe Omotesando)
MAISON BOINET
Belt ¥25,000 (EN ROUTE GINZA)
kei shirahata Bangle(leather) ¥15,000
(styling/Omotesando Hills)
Double Dipper Bangle(silver) ¥150,000
(URBAN RESEARCH
TOKYU PLAZA GINZA)
*T-shirt *RIKACO'S OWN*

GARCONS INFIDELES *Shirt* ¥34,000
(DRESSTERIOR SHINJUKU)
raxmance *Sleeveless shirt* ¥10,000
(journal standard L'essage GINZA)
upper hights *Pants* ¥23,000
(GUESTLIST)
PIPPICHIC
Sandals ¥32,000 *(BEIJU)*

ORIAN *Shirt* ¥19,000
(YAGI TSUSHO)
Hanes *T-shirt* ¥1,800
(Hanesbrands Japan)
SEMIS *Overall skirt* ¥34,000
(AMERICAN RAG CIE SHIBUYA)
LEO STUDIO *Bag* ¥11,000 *(Fred Segal)*
Sneakers *RIKACO'S OWN

Serra Retreat *Shirt* ¥22,000 *(GUESTLIST)*
Steven Alan *Knit skirt* *RIKACO'S OWN
BIRKENSTOCK *Sandals* ¥4,000 *(BIRKENSTOCK SHINJUKU)*
WENDY NICHOL *Bag* ¥258,000 *(TOMORROWLAND)*
Double Dipper *Bangle[top of silver(star)]* ¥150,000 *(URBAN RESEARCH TOKYUPLAZA GINZA)*
ORVILLETSINNIE×BEAMS BOY *Bangle[milddle of silver(plain)]* ¥42,000
[bottom of silver] ¥58,000 *(BEAMS BOY HARAJUKU)*
BEAMS BOY *Bangle[lether]* ¥3,000 *(BEAMS SHINMARUNOUCHI)*

POLO RALPH LAUREN
¥14,000
(RALPH LAUREN)

MOTHER
¥39,000
(The SAZABY LEAGUE)

Frank&Eileen
¥27,000
(The SAZABY LEAGUE)

BARENA VENEZIA
¥39,000
(MUSE de Deuxieme Classe Omotesando)

SWEAT WEAR

毎日スタメンの筆頭アイテム

あまりに私の日常に根差していて「NO SWEAT, NO LIFE！」と言っても過言ではないほど。実はキレイめにも振れる気取りのないアイテムで、その守備範囲の広さは秀逸なのです。色はヘザーグレーとブラックが基本。チャンピオン的なスポーツテイストから少しエッジを効かせたジェームス パースまで同じものをサイズ違いで持つくらい偏愛中。

SEA *Sweat parka ¥32,000 (S-STORE),* SEA *Shirt ¥25,000 (S-STORE)*
Fred Segal *Skirt ¥20,000 (Fred Segal)*

SEA *Sweat parka* ¥32,000 (S-STORE)
SEA *Shirt* ¥25,000 (S-STORE)
Fred Segal *Skirt* ¥20,000 (Fred Segal)
UNITED ARROWS *Shoes* ¥22,000
(UNITED ARROWS HARAJUKU)
RALPH LAUREN *Bag* ¥144,000
(RALPH LAUREN)
Kong qi *Pierced earrings* ¥18,000
(Balata concierge Press Room)
*Socks, Watch *RIKACO'S OWN*

Sweat pants *RIKACO'S OWN
THE SHIRT by upper hights
Shirt ¥26,000 (GUEST LIST)
JIMMY CHOO
Pumps ¥123,000 (JIMMY CHOO)
J & M DAVIDSON *Bag* ¥132,000
(J & M DAVIDSON AOYAMA)
JOJOBA *Bangle* ¥18,000
(TOMORROWLAND)

Sweat pants *RIKACO'S OWN
EQUIPMENT *Shirt* ¥34,000 *(The SAZABY LEAGUE)*
VINCE *Knitwear* ¥44,000 *(VINCE OMOTESANDO)*
CONVERSE *sneakers* ¥9,500
*(CONVERSE
INFORMATION CENTER)*
SMYTHSON *Wallet* ¥95,000
(VULCANIZE London)

SEA *Sweat parka* ¥32,000 (S-STORE)
Sweat pants *RIKACO'S OWN
SEA *Shirt* ¥25,000
(S-STORE)
TOMORROWLAND *Shoes* ¥54,000
(TOMORROWLAND)
REBECCAMINKOFF *Bag* ¥470,000
(UNIT&GUEST)

UNITED ARROWS *Sweat skirt* ¥12,000
(UNITED ARROWS HARAJUKU FOR WOMEN)
Deuxieme Classe *Long coat* ¥20,000
(MUSE de Deuxieme Classe OMOTESANDO)
Happiness *T-shirt* ¥6,500 (GUEST LIST)
MANOLO BLAHNIK *Pumps* ¥99,000
(BARNEYS NEW YORK)
AMERICAN RAG CIE *Bag* ¥8,500
(AMERICAN RAG CIE SHIBUYA)

Traditional Weatherwear
Sweat shirt ¥12,000
(MUSE de Deuxieme Classe OMOTESANDO)

Champion
Sweat shirt ¥5,900
(Hanesbrands Japan)

Fred Segal
Sweat pants ¥16,000
(Fred Segal)

UNITED ARROWS
Sweat skirt ¥12,000
(UNITED ARROWS HARAJUKU FOR WOMEN)

SEA
*Sweat parka ¥32,000
(S-STORE)*

SCARF

オシャレ偏差値UPに必須

　世代によっては馴染みのあるアイテムですが、その使い方はずっとカジュアルになりました。バッグのハンドル巻きは、あえてカジュアルなトートにするギャップが記憶に残ります。やはりエルメスのスカーフは素材自体の艶や発色に風格があるし時代によって異なる柄が本当に美しいので投資するだけの価値があります。カレの90×90cmを基軸に手首に巻くにも丁度いいカレの45×45cmやツイリーも最近仲間入りしています。

HERMÈS *Scarf* *RIKACO'S OWN*, upper hights *Denim jacket* ¥26,000 *(GUESTLIST)*
Hanes *T-shirt* ¥1,500 *(Hanesbrands Japan)*, TIFFANY *Watch* ¥460,000 *(TIFFANY&Co.)*

RALPH LAUREN
*Scarf *Reference item*
(RALPH LAUREN)
Le minor *Top* ¥11,000
(GALERIE VIE MARUNOUCHI)
orslow *Denim pants* ¥16,800 (Bshop)
TIFFANY *Watch* ¥460,000
(TIFFANY&Co.)

SHARE PARK *Scarf ¥5,500*
(ONWARD KASHIYAMA)
RALPH LAUREN COLLECTION
Knitwear ¥87,000 (RALPH LAUREN)
JOURNAL STANDARD *Skirt ¥14,000*
(JOURNAL STANDARD OOTESANDO)
adidas Originals *Sneakers ¥14,000*
(adidas group customer service)
L.L.Bean *Bag ¥5,900*
(L.L.Bean customer servicecenter)
TIFFANY *Bangle ¥60,000*
(TIFFANY&Co.)

HERMÈS
RIKACO'S OWN

[left to right]
UNITED ARROWS
¥9,000
(UNITED ARROWS HARAJUKU FOR WOMEN)
MANIPURI
¥7,800
(JOURNAL STANDARD L'ESSAGE GINZA)
ALEX MILL
¥6,800
(CPCM)

WATCH

普遍的な美しさを感じる

一過性の小物とは違い、大げさかもしれませんが人生の指針となるもの。だから思いつきで買うのではなく自分を託せる伴侶を探すくらいの気持ちで選んだものたちです。大人のオシャレはその人の本質が覗くもの、日常にさりげなく溶け込む「ロレックス オイスター パーペチュアル」のラフなリュクスさが私のオシャレにはフィットします。

ROLEX *Watch *RIKACO'S OWN*, M/G TASAKI *Pierced earrings* ¥175,000 *(TASAKI)*
T-shirt, Scarf *RIKACO'S OWN

Cartier *<Santos Demoiselle>*
¥2,010,000
(Cartier)

IWC *<Portugieser Chronograph>*
¥1,850,000
(IWC)

CHANEL <Première>
*RIKACO'S OWN

HERMÈS <Kelly Watch>
*RIKACO'S OWN

BAG

心がときめくパワー小物

イットバッグに心躍らない女性はいないと思います。正直私もその一人です。でも一流のメゾンブランドだから、流行りだからといった尺度でそのバッグを買うことはありません。いくらバッグ自体が素敵でステイタスを纏えるものだったとしても自分らしく持てなければオシャレには見えないからです。だから私も実はケリー バッグを自分のものとして肩肘張らずに持てるようまだオシャレ レッスンの途中なんです。

HERMÈS Bag *RIKACO'S OWN, **NOMIA** Coat ¥80,000 (UNITED ARROWS HARAJUKU FOR WOMEN)
DRESSTERIOR Pants ¥16,000 (DRESSTERIOR SHINJUKU), Bangle *RIKACO'S OWN

HERMÈS *Bag *RIKACO'S OWN*
NOMIA *Coat ¥80,000*
(UNITED ARROWS
HARAJUKU FOR WOMEN)
Steven Alan *T-shirt *RIKACO'S OWN*
DRESSTERIOR *Pants ¥16,000*
(DRESSTERIOR SHINJUKU)
TOMORROWLAND *Shoes ¥54,000*
(TOMORROWLAND)
*Bangle *RIKACO'S OWN*

CHANEL Bag *RIKACO'S OWN
JOSEPH Top ¥21,000
(ONWARD KASHIYAMA)
DEMYLEE Sweat pants ¥28,000
(The SAZABY LEAGUE)
JIMMY CHOO Pumps ¥74,000
(JIMMY CHOO)
Links of London Pierced earrings ¥175,000
(Links of London Aoyama)
TASAKI Ring ¥430,000
(TASAKI)

RALPH LAUREN
RIKACO'S OWN

HERMÈS
RIKACO'S OWN

CHANEL
RIKACO'S OWN

HERMÈS
RIKACO'S OWN

FENDI
RIKACO'S OWN

VALENTINO
RIKACO'S OWN

SOCKS

意外と重要な役割を担うもの

パンツと足元を繋ぐのには欠かせません。抵抗がある人は黒パンプス×黒ソックスやチャコールグレーのソックスから始めてみてください。私個人は白ソックス×パンプスのちょっとガーリーな雰囲気が残る感じも、ちょっとやんちゃな感じのライン入りソックスも好き。ブルーフォレと靴下屋がソックスの引き出しにたくさんおります。

*Socks, Sneakers *RIKACO'S OWN,* **SEA** *Skirt ¥26,000 (S-STORE)*
RALPH LAUREN *Bag ¥420,000 (RALPH LAUREN)*

Socks, Sneakers *RIKACO'S OWN
MADISONBLUE *Jacket* ¥83,000
(MADISONBLUE
HEAD STORE)
JAMES PERSE *Sleeveless shirt* ¥18,000
(JAMES PERSE AOYAMA)
SEA *Skirt* ¥26,000 (S-STORE)
Pocket *Bangle* ¥26,800 (Pocket)

*Socks *RIKACO'S OWN*
JOURNAL STANDARD *Skirt ¥14,000*
(JOURNAL STANDARD
OOTESANDO)
FABIO RUSCON *Pumps ¥30,000*
(FABIO RUSCONI
YURAKUCHO)

*Socks *RIKACO'S OWN*
RED CARD *Denim pants ¥19,000*
(GUEST LIST)
CONVERSE *Sneakers ¥7,000*
(CONVERSE
INFORMATION CENTER)

EYE WEAR

瞳を神秘的に魅せてくれます

メガネは視線に強さを生み、印象をデフォルメするツール。顔の中央に位置するものだから、そのセレクトは慎重に。フェイスライン、眉との関係性、ツルの太さや長さ、フレームの色と顔色のバランスなど考慮すべき点はたくさんあります。厳しい選考基準を潜り抜けたアイウェアは最強のファッションツールとなるのは間違いありません。

KENDRICK *Glasses* ¥30,000 (OLIVER PEOPLES TOKYO GALLERY)
ENFOLD *Top* ¥23,000 (BAROQUE JAPAN LIMITED), *Pierced earrings* *RIKACO'S OWN

OLIVER PEOPLES *Glasses ¥33,000*
(OLIVER PEOPLES TOKYO GALLERY)
SEA *Shirt ¥28,000 (S-STORE)*
NATURALI JEWELRY *Pierced earrings ¥12,000*
(NATURALI)

MAX PITTON *Sunglasses ¥39,000 (the LIGHT)*
Room no.8 *Long gillet ¥54,000 (otto design Ltd.)*
*Sleeveless Shirt, Bangle *RIKACO'S OWN*

KENDRICK
¥30,000
(OLIVER PEOPLES TOKYOGALLERY)

MAX PITTON
¥39,000
(the LIGHT)

Oliver Goldsmith
¥28,000
(blinc vase)

PRADA
¥28,000
(MIRARI JAPAN)

DAILY COORDINATE

365日は残念ながらお見せできないですが、日々の私のスタイリングが気になると言ってくださる方も多いのでリクエストに応えて何年か前までさかのぼったスナップをシェアします…。

SPRING

SUMMER

135

AUTUMN

137

WINTER

139

ARCHIVE

ちょっと恥ずかしいけど私の変遷です。
息子に言われた「僕らが生まれる前のお母さんも見てみたい。
お母さんの歴史ってやつ」というのがここで少しわかってもらえ
るかな。息子たちに、そして皆さまに自分が一生懸命やってきた
ことをこうした形で見て貰える私はやっぱり幸せですね。

IO'S

『mc Sister』(1984年4月号/婦人画報社)

20'S

30'S

『Ray』(1995年7月号/主婦の友社)

『マフィン』(1996年2月号/小学館)

『como』(1995年12月号/主婦の友社)

40'S

[「STORY」/2008年1月号/光文社]

[「STORY」/2008年3月号/光文社]

[「STORY」/2009年1月号/光文社]

[「STORY」/2010年6月号/光文社]

[「STORY」美スト Beauty Body Book/2011年10月/光文社]

[「Harper's BAZAAR/2015年1月号/ハースト婦人画報社]

143

4o's

「GLAMOROUS」別冊付録『Glamorous Mama グラマラス・ママ―美しき12人の愛のかたち』(2010年2月号/講談社)

144

Books

「Style book RIKACO'S SELECTION」(1995年/主婦の友社)

「HOME」(2011年/主婦と生活社)

「RIKACO'S ALOHA STORY」(2012年/光文社)

「RIKACO'S ALOHA STORY 2」(2015年/光文社)

Stylist_TSUGUMI WATARI
Photographer_RINTARO ISHIGE
Hair & Make-up_MIKAKO KIKUCHI

RALPH LAUREN COLLECTION *Dress (RALPH LAUREN)*

RIKACO X STYLIST
COLLABOLATION

私のモデル人生に置いて深く関わりのあったスタイリストの方々にお願いをして、
そのスタイリストの方々の思う「RIKACO」を表現して頂きました。
それぞれ仕事をしていた年代で、私に抱く印象がさまざまなのが印象的でした。
この本を手に取ってくださった皆さんが私に抱く印象はどんなんなんだろう…

UNISEX T-shirt (H BEAUTY & YOUTH)
Denim pants (ISETAN SHINJUKU WOMEN'S Re-Style TOKYO)
J.M.WESTON Shoes (J.M. WESTON AOYAMA)
FANTASTICMAN Bangle (FANTASTICMAN TOKYO)

147

Stylist_KEISUKE BABA

Photographer_YASUTOMO EBISU
Hair & Make-up_MIKAKO KIKUCHI

Lewis Leathers *Biker jacket* ¥180,000 (DAVIDS CLOTHING)
VERSUS VERSACE *Dress* ¥106,000 *Pants* ¥47,000 (VERSACE JAPAN)
Christian Louboutin *Sneakers[Men's]* ¥165,000 (Christian Louboutin Japan)

Stylist_KAZ IJIMA
Photographer_HIROSHI KUTOMI
Hair & Make-up_MIKAKO KIKUCHI

YOHJI YAMAMOTO *Shirt dress* ¥68,000 (YOHJI YAMAMOTO PRESSROOM)
GRECO *Bangle* ¥10,000 (DEPECHE MODE EBISU SHOP)

GIORGIO ARMANI *Poncho* ¥250,000 *Sandals* ¥125,000 (GIORGIO ARMANI JAPAN)
Denim pants, Belt ＊STYLIST'S OWN

151

Stylist_MIYUKI MORI
Photographer_NOBORU MORIKAWA
Hair & Make-up_ISAO TSUGE

153

RIKACO&REN

156

気づけば13歳から、ファッションと深い関わりを持って生きてきました。
健康な体づくりのための食生活やエクササイズもすべて
最終的にはオシャレをすることに繋がりがあります。

自分にとって大きな区切りのひとつとなる今年。
何か形にできたらいいなぁ…とここ数年ずっと考えていた私を
後押ししてくれたのは長男の言葉でした。
「やっぱり、ファッションなんじゃないの、お母さんは。
オシャレに興味がそんなにない僕だって、お母さんがオシャレを
どう捉えているか興味あるもん。蓮(次男)の日々のコーディネートに
対する情熱のかけ方だって完全にお母さんのDNAでしょ」
そこから一念発起し準備を始めて1年、再確認したのは
装っては迷いを繰り返し、少しずつ時間をかけ、答えを見つけた精鋭たちは
10代の昔からずっと変わらないってこと。

ずっと着続けているものには愛着があるから自然と体に馴染むし、
自分らしく、自分のものとして着こなしているから雄弁になる。
もちろん好きなものが同じだからと言って進化がないわけじゃない。
微妙な丈感、シルエット、もしかしたら色合わせかもしれない。
そこには時代背景や年齢に沿ったしなやかな発想の転換と好奇心が必要。
それがオシャレを錆びさせないための大切なルール。
この一冊が自分にとってオシャレを託せるベーシックが何か、
オシャレを少しだけ深く考えるきっかけになっていただけたら嬉しいです。
そして読み終わっても、皆さまのお傍にいつでもあることを心より願って…。

RIKACO

SHOP & PRESS LIST

5eme VISAGE co.,ltd 03-5738-2045
adidas group customer service 0570-033-033
AMERICAN RAG CIE SHIBUYA 03-5459-7300
Balata concierge Press Room 03-6303-0036
BARNEYS NEW YORK 0120-137-007
BAROQUE JAPAN LIMITED 03-5428-6051
BEAMS BOY HARAJUKU 03-5770-5550
BEAMS SHINNMARUNOUCHI 03-5288-7670
BEIJU 03-6434-0975
BerBerJin 03-3401-4666
Bilitis 03-3403-0320
BIRKENSTOCK SHINJUKU 03-5919-3369
blinc vase 03-3401-2835
BONUM OMOTESANDO 03-5464-3056
Bshop 03-6427-3710
BURBERRY JAPAN 0066-33-812819
Cartier 0120-301-757
Christian Louboutian Japan 03-6804-2855
COCOSHNIK 03-3497-1309
COCOSHNIK ONKITSCH YURAKUCHOMARUI 03-3213-5049
CONVERSE INFORMATION CENTER 0120-819-217
Cruciani Ginza 03-3573-6059
CPCM 03-3406-1104
DAVIDS CLOTHING 03-3409-8822
DEPECHE MODE EBISU SHOP 03-3442-2220
DRAWER AOYAMA 03-5464-0226
DRESSTERIOR SHINJUKU 03-3344-8015
Edition OMOTESANDOHILLS 03-3403-8086
EN ROUTE GINZA 03-3541-9020
FABIO RUSCONI ROPPONGI 03-3408-8682
FABIO RUSCONI YURAKUCHO 03-6268-0538
FANTASTIC MAN TOKYO WWW.FANTASTICMAN.JP
Fred Segal 03-6892-1020
G-Star International 03-5765-3301
GALERIE VIE MARUNOUCHI 03-5224-8677
GIORGIO ARMANI JAPAN 03-6274-7070
GLOBE-TROTTER GINZA 03-6161-1897
GUEST LIST 03-6869-6670
Hanesbrands Japan[Champion] 03-5361-2860
Hanesbrands Japan[Hanes] 03-5361-2823
haunt DAIKANYAMA 03-5728-8797
H BEAUTY&YOUTH 03-6434-5230
HEMT PR 03-6427-1030
HIGH BRIDGE INTERNATIONAL 03-3486-8847
INTERLIB INC. 03-6416-1861
ISETAN SHINJUKU WOMEN'S Re-Style TOKYO 03-3352-1111
IWC 0120-05-1868
J.M. WESTON AOYAMA 03-6805-1691
J&M DAVIDSON AOYAMA 03-6427-1810

JIMMY CHOO 03-5413-1150
JOURNAL STANDARD L'ESSAGE GINZA 03-5524-2200
JOURNAL STANDARD OMOTESANDO 03-6418-7958
L.L.Bean customer servicecenter 0120-812-200
Lea mills agency 03-3473-7007
Lieto 03-5413-5333
Links of London Aoyama 03-3408-4509
LYDIA 03-3797-3200
MADISONBLUE HEAD STORE 03-5724-3339
Masterpiece showroom 03-5468-3931
Mila Owen LUMINE Shinjuku2 03-6380-1184
MIRARI JAPAN 03-5138-6478
MUSE de Deuxieme Classe OMOTESANDO 03-5413-3731
NATURALI 03-6721-1570
NDC JAPAN 03-5457-1286
OLIVER PEOPLES TOKYOGALLERY 03-5766-7426
ONWARD KASHIYAMA 03-5476-5811
otto design Ltd. 03-6804-9559
Pocket 03-6804-6755
RALPH LAUREN 0120-327-420
RAWTUS INTERNATIONAL 03-5452-2529
ROKU BEAUTY&YOUTH SHINJUKU 03-5361-6130
S-STORE 03-6432-2358
SENSE OF PLACE by URBAN RESEACH Q PLAZA HARAJUKU 03-6433-5548
showroom SESSION 03-5464-9975
Sojitz GMC 03-6894-5760
STETSON JAPAN 03-5652-5890
STEVEN ALAN TOKYO 03-5428-4747
STRASBURGO 0120-383-653
styling/omotesando hills 03-6721-1878
TASAKI 0120-111-446
the LIGHT 03-6447-2666
The SAZABY LEAGUE 03-5412-1937
TIFFANY&Co. 0120-488-712
TOMMOROWLAND 0120-983-511
UNIT & GUEST 03-3710-3107
UNITED ARROWS HARAJUKU 03-3479-8176
URBAN RESEARCH ROSSO LUMINE YURAKUCHO 03-6268-0578
URBAN RESEARCH TOKYUPLAZA GINZA 03-6264-5695
VANS JAPAN 03-3476-5624
VERSACE JAPAN 03-3569-1611
VINCE OMOTESANDO 03-6804-1224
VULCANIZE London 03-5464-5255
Whim Gazette Aoyama 03-5778-4311
YAGI TSUSHO 03-6809-2183
YOHJI YAMAMOTO PRESSROOM 03-5463-1500
ZARA JAPAN 03-6415-8061

Direction_RIKACO
Photography_KAZUKI NAGAYAMA (S-14)<RIKACO>, AYA SATO<STILL>
Styling_MAKOTO FUKUDA, HAMAKO TAKEMURA
Hair_KOICHI NISHIMURA(angle management produce)
Make-up_FUMIHIRO KAWAHARA(takahashi office)
Art Direction_TOMOYUKI YONEZU(EROTYKA TOKYO PARIS/W)
Text_YUKI OBANA
Edit_TORU UKON, MEGUMI SHIBAZAKI(Righters)

RIKACO_JOURNAL STANDARD Sleeveless Knitwear ¥11,000 (JOURNAL STANDARD OMOTESANDO)
RE/DONE *Denim pants ¥43,000 (Fred Segal), Sneakers, Bandanna *RIKACO'S OWN*
REN_AMERICAN RAG CIE *T-shirt ¥5,000 (AMERICAN RAG CIE SHIBUYA)*
Levi's® *Denim pants *Vintage ¥79,800 (BerBerJin),* **VANS** *Sneakers ¥7,000(VANS JAPAN)*

2016年6月24日　初版第1刷発行

著者　　RIKACO
発行人　森雅貴
発行所　LDH Inc.
　　　　〒104-8238 東京都中央区銀座5-15-1-SP614
　　　　編集部 TEL 03-6692-1489

印刷・製本　図書印刷株式会社

©LDH 2016, Printed in Japan
ISBN 978-4-908200-05-2

本誌に掲載の商品価格はすべて税抜き価格表示です。価格は2016年6月24日時点の内容です。
禁・無断複製／無断転載　落丁・乱丁の場合はお取り替えいたします。
本媒体の無断複製（コピー、スキャン、デジタル化等）は禁じております（ただし著作権上での例外は除く）。
許可なく写真・文章等をスキャンやデジタル化することは著作権法違反に問われる可能性があります。